CROMER &
SHERINGHAM

HISTORY TOUR

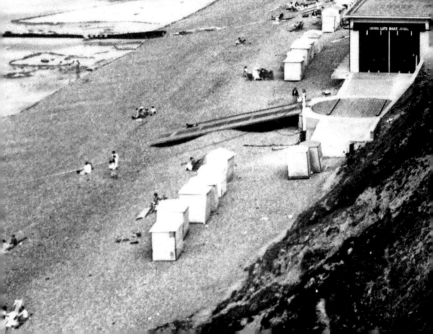

ACKNOWLEDGEMENTS

In 1982, I wrote *Coastal Resorts of East Anglia, the Early Days* for Terence Dalton. I have relied on the original research I did for that for much information. I have also enjoyed *The North Norfolk Coast* and *The Lost Coast of Norfolk* by Neil Storey. In 2010 I wrote *Cromer and Sheringham Through Time* for Amberley Publishing. All the old photographs are in my own collection and all the modern ones were taken by me.

Michael Rouse
Ely, 2015

First published 2016

Amberley Publishing
The Hill, Stroud,
Gloucestershire, GL5 4EP
www.amberley-books.com

Copyright © Michael Rouse, 2016
Map contains Ordnance Survey data
© Crown copyright and database right
[2016]

The right of Michael Rouse to be
identified as the Author of this work
has been asserted in accordance with
the Copyrights, Designs and Patents
Act 1988.

ISBN 978 1 4456 5705 9 (print)
ISBN 978 1 4456 5706 6 (ebook)

British Library Cataloguing in
Publication Data.
A catalogue record for this book is
available from the British Library.

Typesetting by Amberley Publishing.
Printed in Great Britain.

INTRODUCTION

'He who would Old England win
Must at Weybourne Hoop (Hope) begin.
Cromer crabs, Runton dabs,
Beeston babies, Sheringham ladies,
Weybourne witches, Salthouse ditches'
Old Norfolk place names rhyme

Weybourne to Cromer are on the ancient Peddars Way and the Norfolk Coastal Path. Crumbling cliffs and lost settlements – this stretch of the Norfolk coast from Weybourne to Sidestrand has it all. This is a tour along a beautiful wild coast once the haunt of fishermen and smugglers transformed by large landowners, like the Upchers at Sheringham Hall, the Bond Cabbells at Cromer Hall and Lord Suffield at Gunton Hall, who could see the benefits of cashing in on the new fashion for taking the sea air and the sea water cures.

The possibility of a visitor and holiday industry brought hope of economic prosperity and before the age of the motor car, it was the Great Eastern and the Midland and Great Northern Railway companies who would open up the Norfolk Coast in the second half of the nineteenth century.

Even after the arrival of the Great Eastern Railway at Cromer in 1877 the town had not developed as quickly as hoped. The Bond

Cabbells at Cromer Hall had huge investments at stake, as did others. In 1883 the editor of the *Daily Telegraph*, probably at the instigation of the Great Eastern Railway Company, sent Clement Scott, his theatre critic and travel writer, to visit Cromer.

It was Scott who walked along the cliffs from Cromer and came across the old ruin of Sidestrand church, with its tower left on the cliff top as a landmark for shipping. From there he strolled through the fields of poppies until he came across the Mill Cottage and the maid of the mill – the shy ninetee-year-old Louie Jermy. Scott stayed at Mill Cottage, wrote about his experiences in articles and then in the book *Poppyland* and so the romance of this part of the Norfolk Coast was born. Scott died in 1904, and in 1909 his friends raised a memorial to him at the junction of the Northrepps and Overstrand Roads. Eventually Louie Jermy's cottage, like the old church tower at Sidestrand, fell victim to the sea, but the attractions of this beautiful part of the Norfolk coast are as compelling as ever.

This tour takes us along from what one writer called 'the wrong side of Cromer', from Weybourne to Sheringham through East and West Runton, then Cromer and towards Overstrand, once one of the most fashionable places in the country boasting numerous millionaires with homes there. This is an area very popular with caravanners but Sheringham and Cromer have managed to avoid the excesses and vulgarity of some seaside towns. For quieter walking holidays, though, bear in mind this part of the coast is not as flat as other sections, but for sea and sand and simpler pleasures this part of the Norfolk coast is ideal.

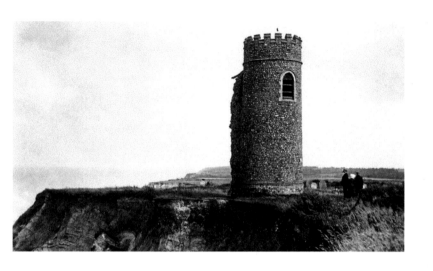

The Garden of Sleep, Sidestrand

'On the grass of the cliff, at the edge of the steep, God planted a garden
– a garden of sleep!'

The Romance of Poppyland and this part of the North Norfolk coast was really begun by the writer Clement Scott in 1883 as he walked eastwards from Cromer and came across the ruined church at Sidestrand which was slipping over the cliff. The church had been rebuilt further inland in 1881 using flint from the original, leaving the tower and the graveyard to its fate. Scott wrote the sentimental poem 'The Garden of Sleep' which became a popular song, appealing to the Victorian obsession with death.

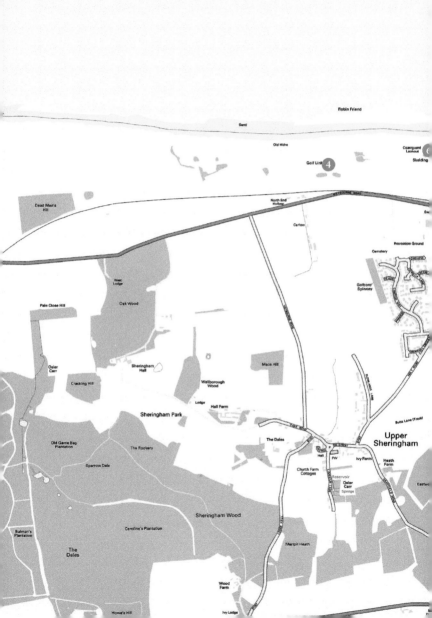

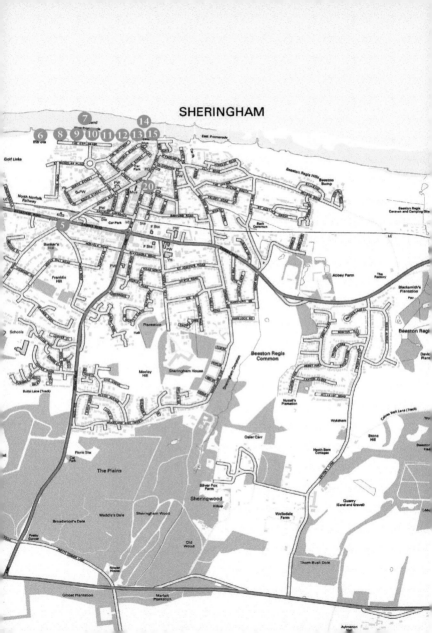

SHERINGHAM

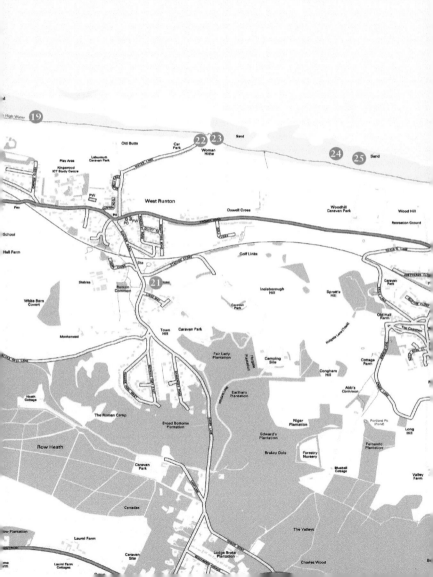

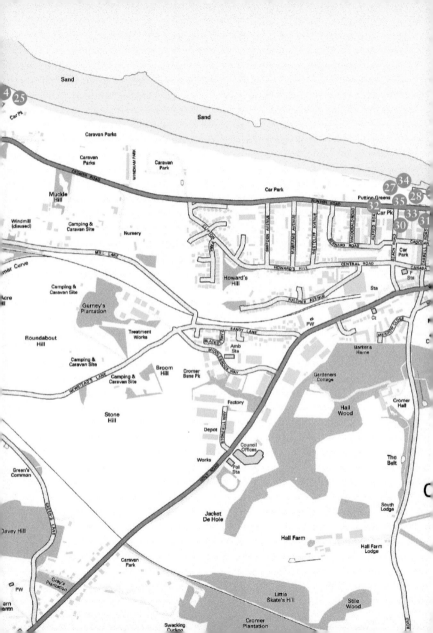

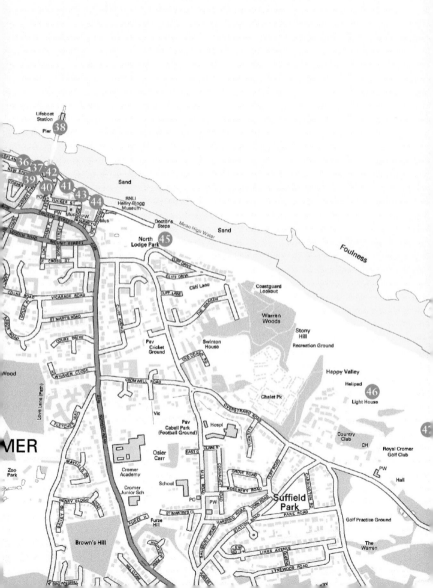

1. THE OLD COASTGUARD STATION, WEYBOURNE

It is said that the ancient Angles first landed at Weybourne and Danish invaders made several raids here. The beach is so steep that large vessels can get close to the shore, thus making Weybourne convenient for any invasion. The Spanish Armada and Napoleon, it was thought, would land here and as a result this part of the coast has always been well defended, as the nearby Muckleburgh Collection testifies. Inset shows where the shingle spit of Blakeney Point meets the coast. The old coastguard station has long gone.

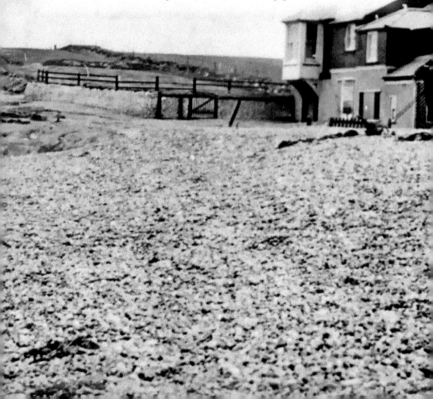

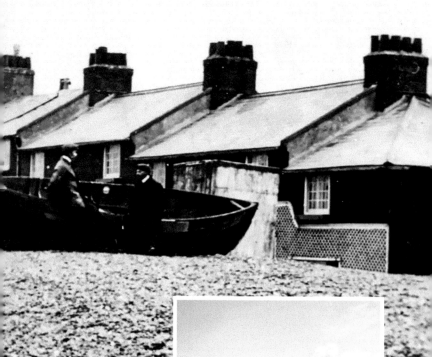

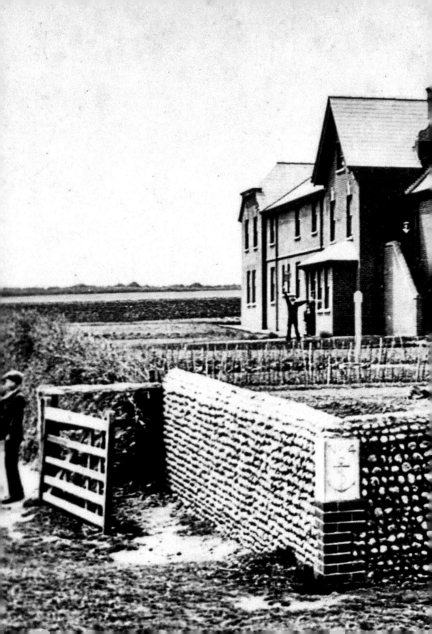

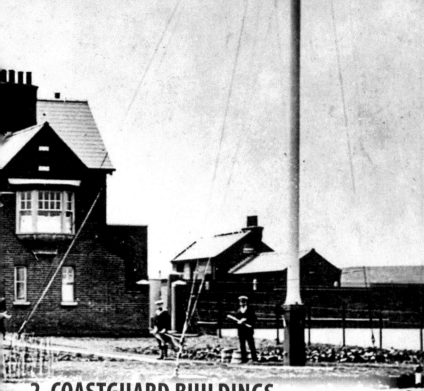

2. COASTGUARD BUILDINGS, WEYBOURNE

Approachable by a very narrow lane, past the 1850 red-brick tower mill, this coastguard station was higher up on the cliffs and replaced the beach station just before the First World War. Over the last 100 years the sea has eroded the cliffs so much so that the wall has gone and it is difficult to photograph the whole building without falling over the cliff edge. During the Second World War the beach was heavily mined and there was a highly secret anti-aircraft artillery range at Weybourne Camp.

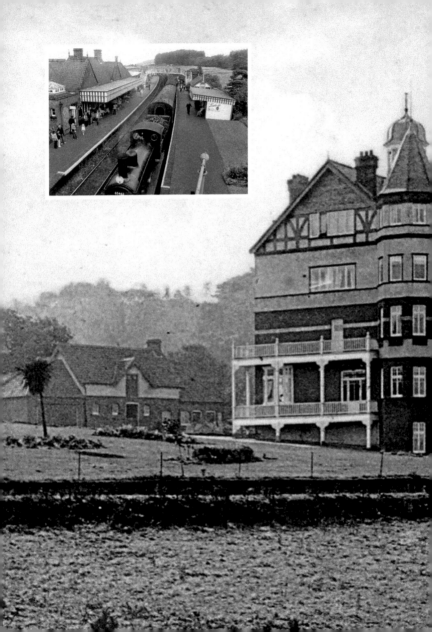

3. SPRINGS HOTEL C. 1908

The Springs Hotel, so-called due to the nearby springs which were reputed to have medicinal properties, was never really successful. As the sender of this card writes in about 1908: '65 of us are at a Bible School ... this is a very isolated place, a mile from the coast.' It was built in 1900 when the railway station opened nearby. The Springs Hotel was demolished around 1940, but the station has been revived by the North Norfolk Railway enthusiasts on the Poppyline from Holt to Sheringham.

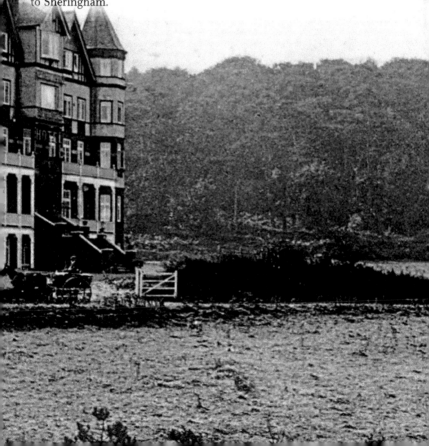

Sheringham Golf Links.

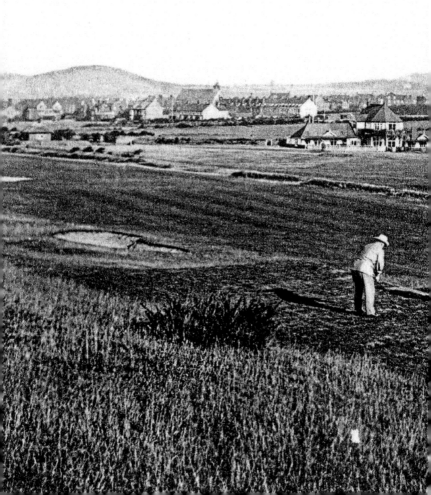

4. SHERINGHAM GOLF LINKS

A nine-hole golf course was laid out on the West Cliff in 1891 and soon extended to eighteen holes. The impressive Sheringham Hotel can be seen in the distance.

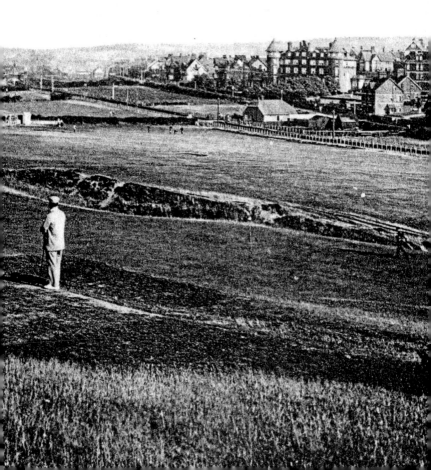

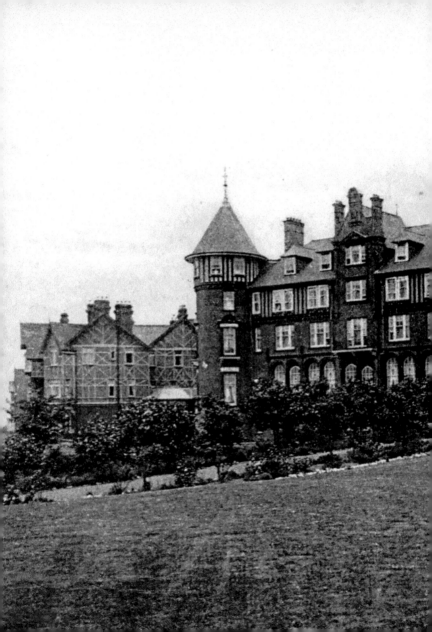

5. THE SHERINGHAM HOTEL

The Sheringham Hotel, designed by George Skipper of Norwich, one of the greatest British architects, was opened in 1891 on the corner of the Weybourne and Holt Roads. It was converted into flats some years ago. In 1889 the Sheringham Gas & Water Co. was formed. There was a Sheringham Development Co. under the superintendence of William Marriott, which undertook the drainage of the town.

BEACH AND LIFE-BOAT STATION, SHERINGH

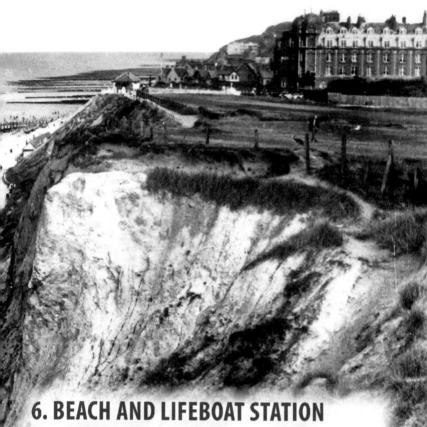

6. BEACH AND LIFEBOAT STATION

The current lifeboat house replaced the one at Fishermen's Slope and opened in 1936 at the West Cliff end of the promenade. It now houses an inshore lifeboat *The Oddfellows* donated by the Manchester Unity Order of Oddfellows. It is an Atlantic 85 rigid inflatable boat. Like all lifeboats it is manned by volunteer crew and continues the noble tradition of saving lives in peril on the sea.

G 7644

7. BURLINGTON AND GRAND ON THE WEST CLIFF

The Grand, on the right, opened in 1898 and the Burlington the next year. Members of many of the wealthier families would stay for 'the Season' and be seen promenading beside the sea. The Esplanade had it own shelters, toilets and archway sloping east and west to the lower promenade. This was later complemented below it by a long shelter with a sun deck. The sands are beautiful beyond the shingle ridge.

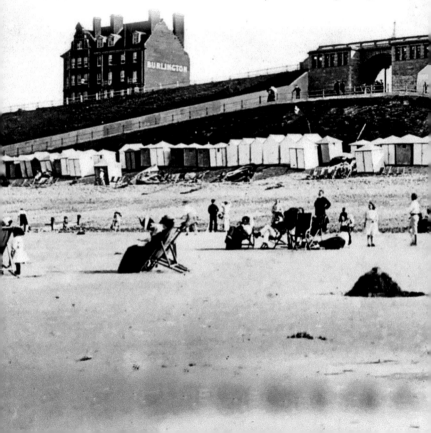

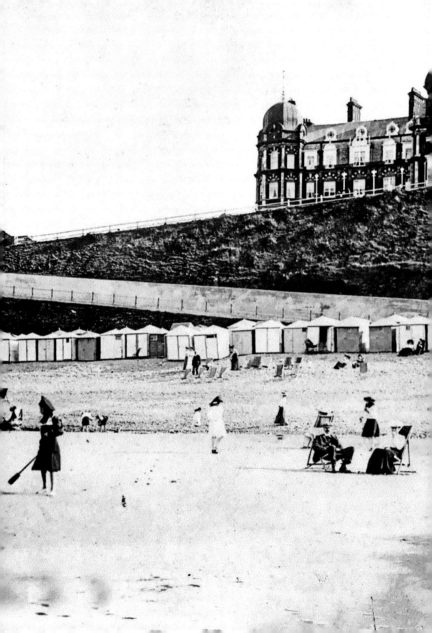

8. THE GRAND HOTEL, SHERINGHAM

The Grand Hotel was designed by H. J. Green of Norwich on the Leas, a symbol of the 'Golden Age' of Sheringham. It was a well-planned development with the Boulevard leading to St Nicholas Gardens and then going on to a T-shaped Esplanade. Sadly the Grand was demolished in 1974 and replaced by modern apartments. The boating lake opposite with its fine traditional shelter, however, remains as a reminder of those years of great optimism.

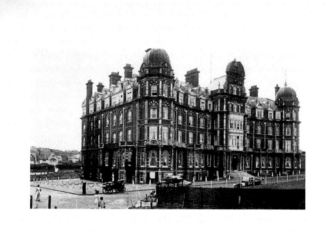

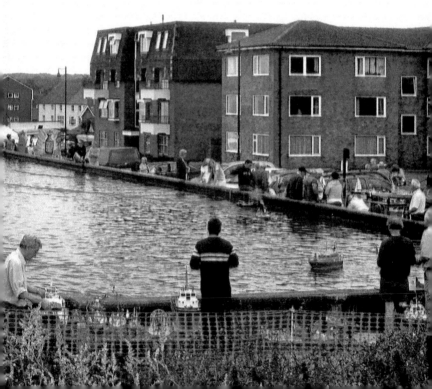

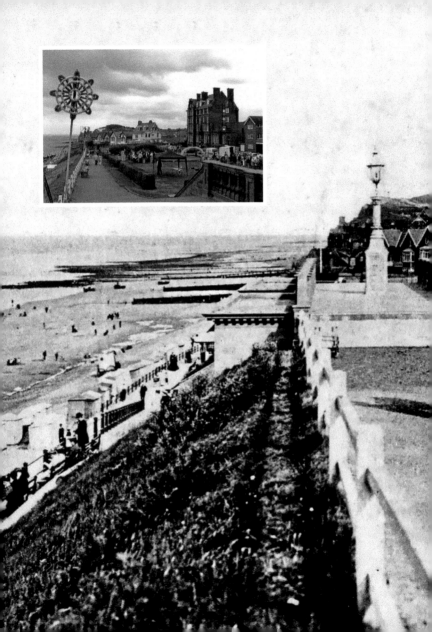

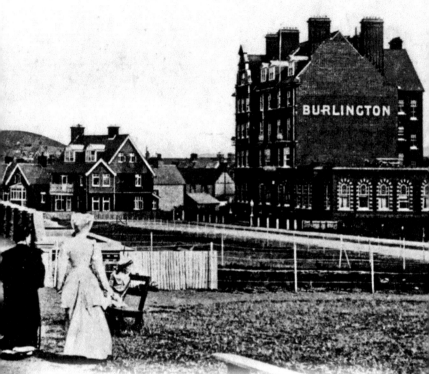

9. SHERINGHAM FROM WEST CLIFF

It was the railway that made Sheringham. By the mid-1890s the Great Eastern Railway Company and the Midland and Great Northern, known affectionately as the 'Muddle and Get Nowhere', had opened up much of rural Norfolk. It was the Midland and Great Northern from its hub at Melton Constable that took the line through Weybourne to Sheringham and Cromer and that had built the Springs Hotel at Weybourne.

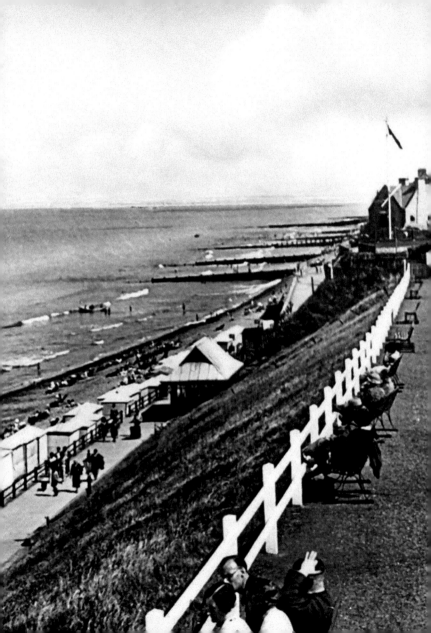

10. WEST PROMENADE, SHERINGHAM

Sheringham's clifftop position gave the opportunity to develop promenades at two levels and link them by steps. Along the top of the West promenade were gardens and the fine hotels; down below was the promenade with the beach huts. In 1906 in *The Bystander* Eric Clement Scott, under the heading of 'A New Seaside Resort', described Sheringham as 'the paradise of the potterer'. He also refers to the resort growing up on 'the wrong side of Cromer' and calls Sheringham 'a friendly rival of Overstrand'.

11. BEACH TENTS

One of Sheringham's early holiday pioneers was Robert Thomas Grimes Pegg, known as 'Gofather' Pegg, one of the Sheringham fisher community. In 1883 he recorded thirty visitors that summer and, noticing visitors undressing on the beach, he supplied five tents for hire. This number increased to sixty bell tents before he provided lockable huts. He held the beach huts and beach chair monopoly for fifteen years as well as offering boat trips and teaching swimming.

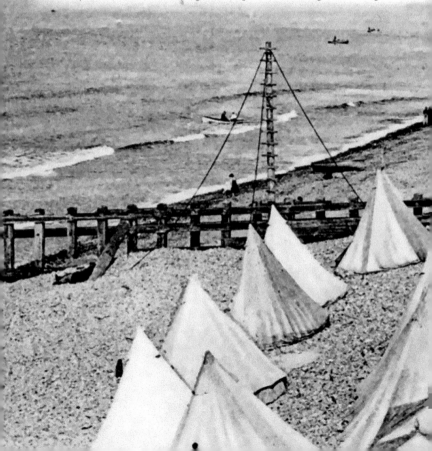

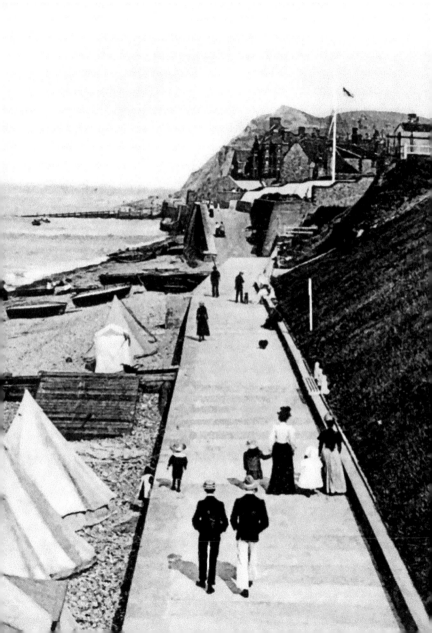

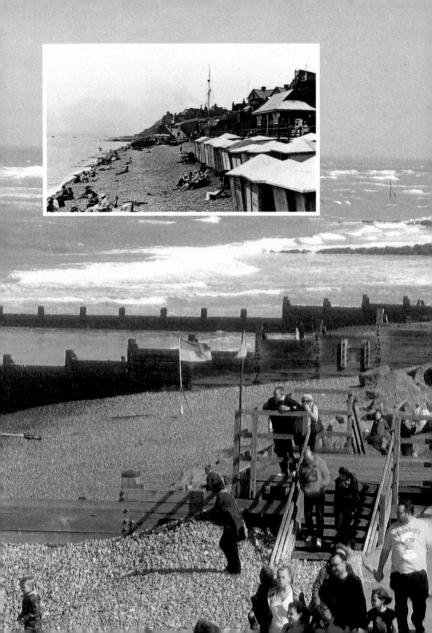

12. THE SHORE LOOKING EAST

Everyone is wearing a hat. The huts lean on the shingle ridge just below the promenade. The flagpole at the coastguard station can be clearly seen. The view today is very different with the large rocks having been brought in to line the shingle below the promenade. The modern huts are now at the back of the promenade. The red and yellow flag marks one end of the bathing area, while the lifeguards watch from a yellow hut on the promenade.

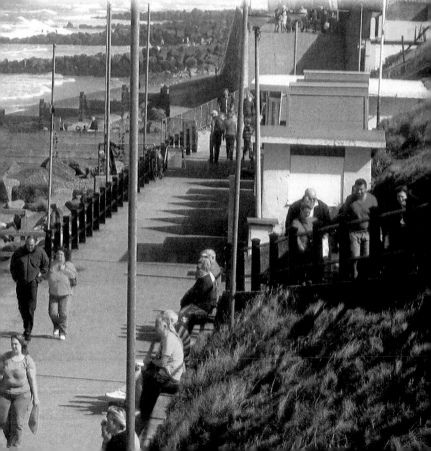

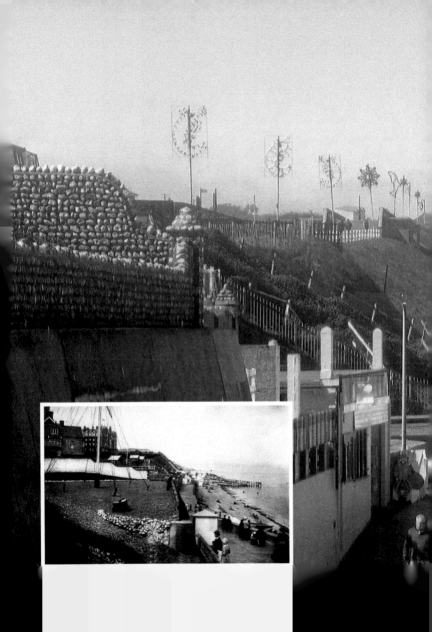

13. PROMENADE FROM COAST GUARD STATION

Occupying a prominent position high on the cliff in the centre of the promenade close by the lifeboat station the Coast Guard Station commanded clear views of the coast. Inset is an early 1920s photograph. HM Coastguard withdrew visual watch in 1994. The nearest Coast Guard rescue co-ordination centre is at Great Yarmouth.

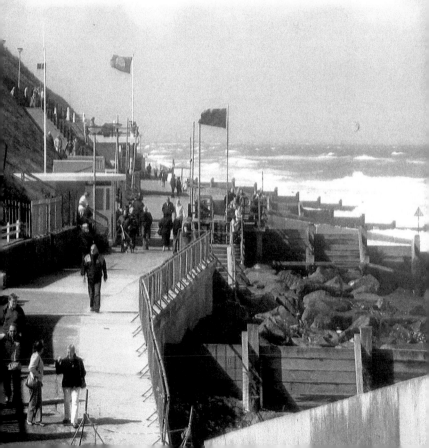

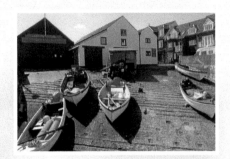

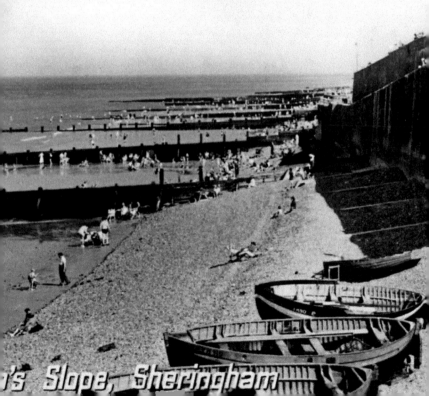

's Slope, Sheringham

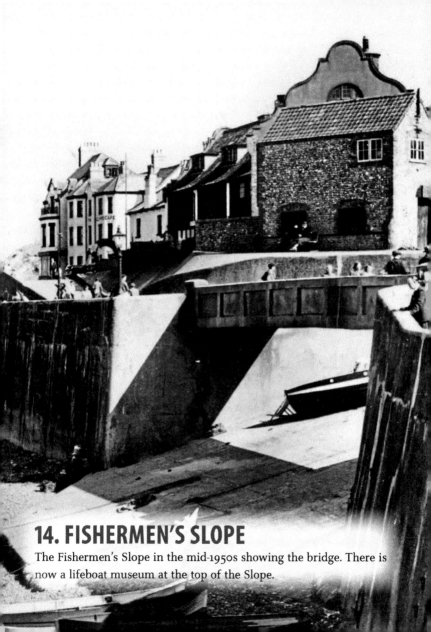

14. FISHERMEN'S SLOPE

The Fishermen's Slope in the mid-1950s showing the bridge. There is
now a lifeboat museum at the top of the Slope.

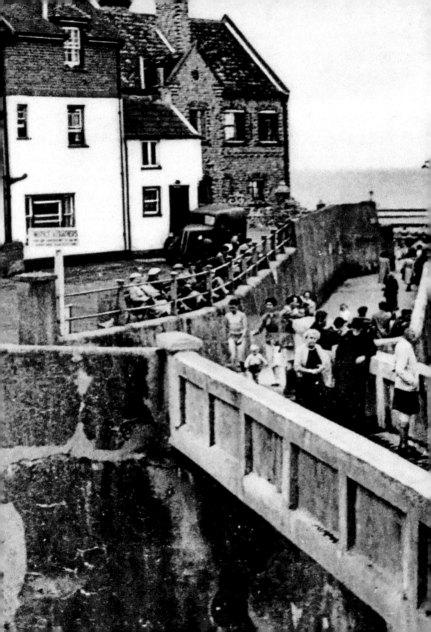

15. BRIDGE GANGWAY

The Fishermen's Slope was where the lifeboat was stationed. For many years Sheringham had two lifeboats. The *Henry Ramey Upcher* was given by his widow in 1866 and from the 1880s the Royal Lifeboat Institution also provided a lifeboat. In 1879 the Two Lifeboats Coffee House was opened. The *Henry Ramey Upcher* lifeboat, between 1894 and 1935, had a twenty-eight-man crew and saved over 200 lives.

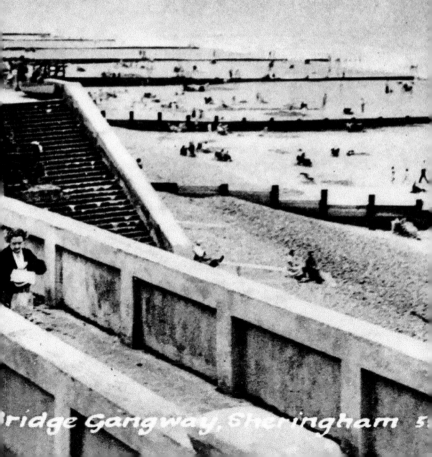

Bridge Gangway, Sheringham 5

16. EAST CLIFF AND PROMENADE

There is variety to Sheringham's promenade and where Beach Road comes down to the water there has been considerable change from Edwardian times. New shelters and new steps now lead up to a clifftop car park with a shop and a first floor café. Some of the houses are easily recognisable while at the top of the cliffs modern flats and new houses have replaced the old. This is now a busy and popular section of the front.

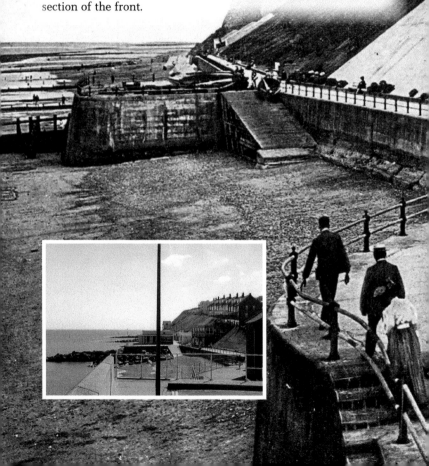

17. EAST PROMENADE AND BEACH

Looking back at the same scene, the Mo, the striking new museum with its observation tower has been built. The £1.1-million project opened Easter 2010 and is billed as 'a place of people and boats'. The viewing tower opened in 2011 and gives some stunning views not just of the coast but also of the new Sheringham Shoal offshore windfarm. A Heritage Lottery grant has funded an ambitious expansion and the museum will reopen in 2016.

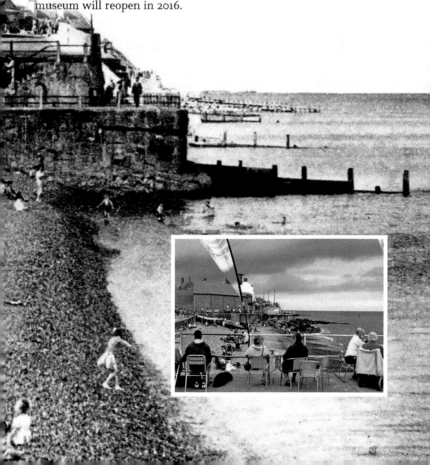

18. EAST BEACH AND CLIFF

The row of brightly coloured beach huts still stretches down the promenade under the cliffs towards the old cloakroom and steps to the clifftop at the far end. The sea defences mean that it is no longer possible for there to be a row of huts along the beach.

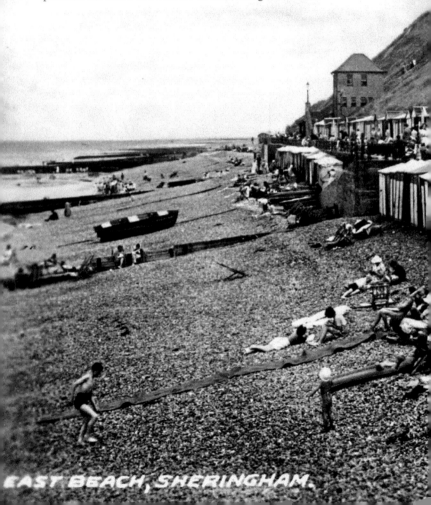

EAST BEACH, SHERINGHAM.

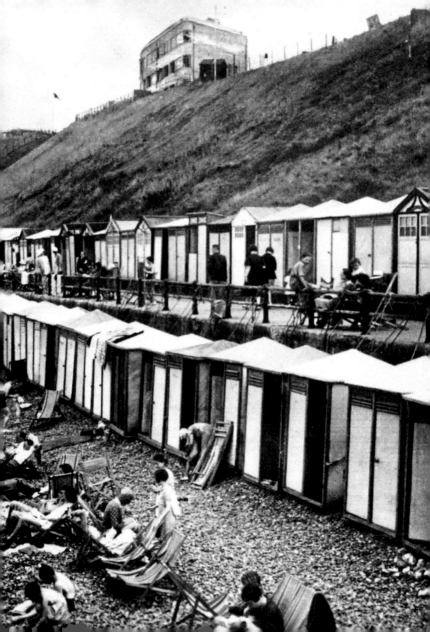

19. MINIATURE GOLF COURSE

Probably mid-1930s and the miniature golf course has been opened and the art deco Queen Mary House apartment block has been built. Does anyone ever play mini-golf or crazy golf other than on holiday?

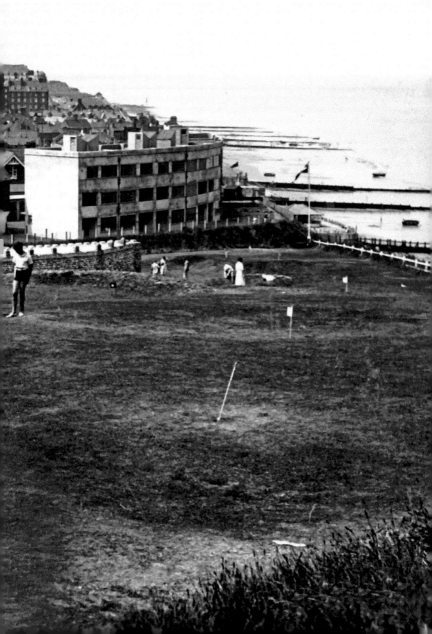

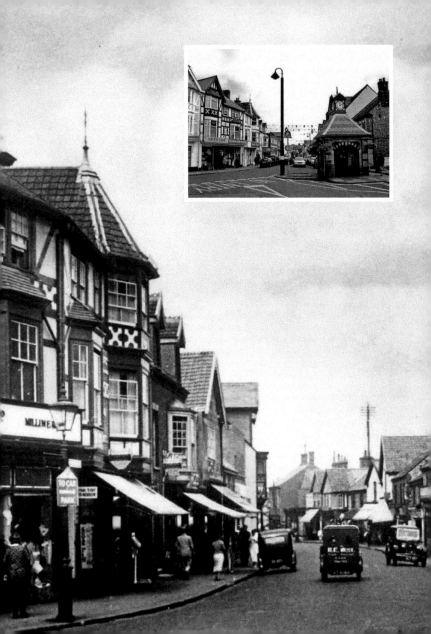

20. HIGH STREET, SHERINGHAM C. 1947

The High Street retains most of its features but has added many more cars and attempts to direct and manage them. It is a busy, lively High Street with a good mix of shops. The Little Theatre nearby in the town centre provides entertainment all year and a particularly popular summer repertory season. The old town reservoir built in 1862 is on the right, the old horse trough has gone, but the clock presented by Mary Pym as an Easter gift in 1903 is still there.

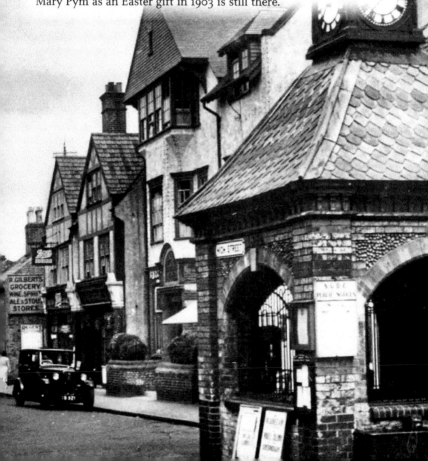

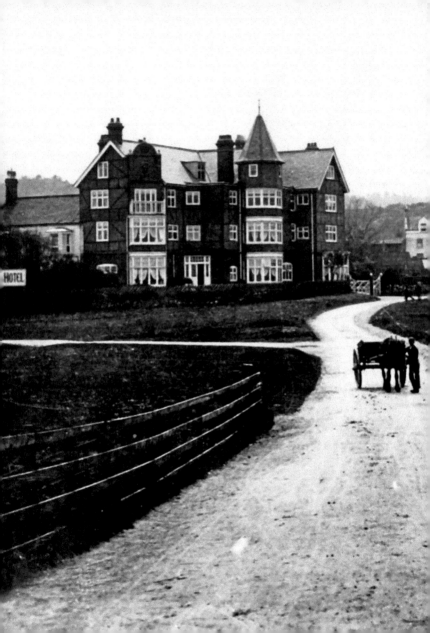

21. WEST RUNTON

Eric Clement Scott in 1906 was also full of praise for West Runton 'the prettiest spot around' and particularly liked the golf course. The Runton Links Hotel was built in 1899, close to the railway station, and set in thirty-five acres of beautiful countryside. Taken over by the War Office in 1940 as a training area, the hotel re-opened in 1950 with a nine-hole course. The Links Country Hotel and the Bittern Line railway are still open.

22. ENTRANCE TO THE BEACH, WEST RUNTON

The West Runton gap leads to the beach where there is now a large car park and café. A blue plaque on the Village Inn commemorates the West Runton Pavilion which was demolished in 1986 but once hosted some of the great names in popular music as Chuck Berry, T-Rex, Black Sabbath through to the Sex Pistols.

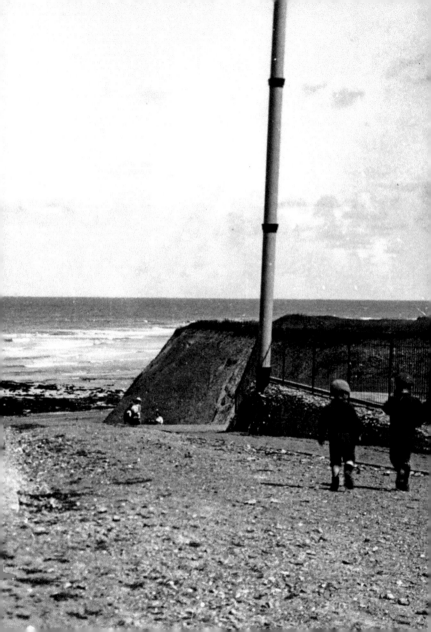

23. THE BEACH

In Edwardian times beach huts and tents lined the foot of the cliffs. Now there are strong sea defences providing a raised walkway. Caravans nestle in the clifftop hollow. When the tide goes out an area of rocks is exposed but also acres of beautiful sand and a distant glimpse of Cromer Pier.

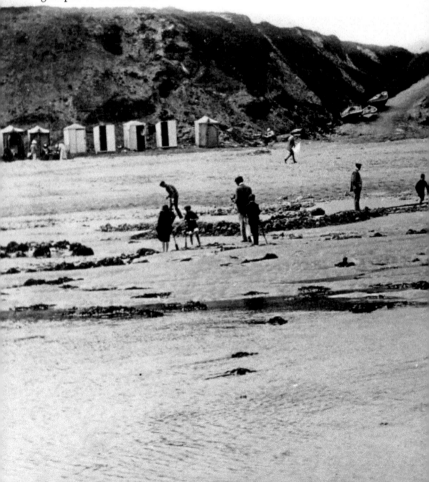

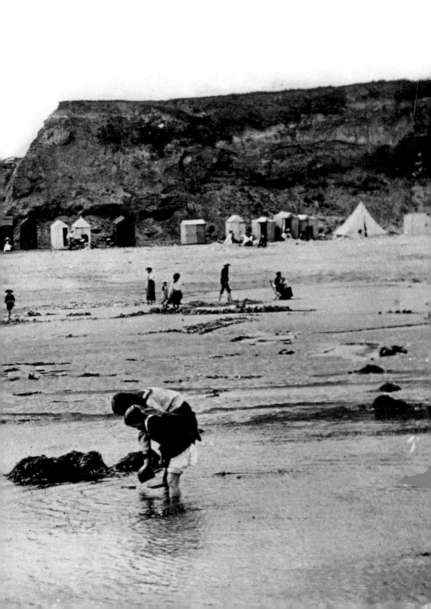

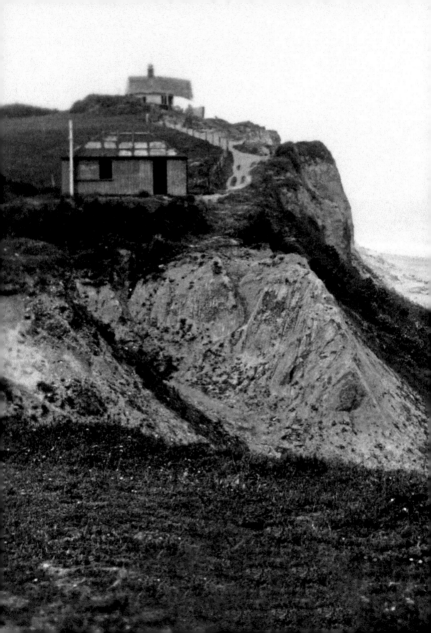

24. EAST RUNTON CLIFFS

The growth of caravan sites since the war has transformed East Runton, but the village still has a quiet green and pond and remains relatively unspoilt. If anything there is less activity on the beach than there used to be. Certainly the rows of huts are not there. This whole section of coast has been affected by changing patterns of tides and rising water levels.

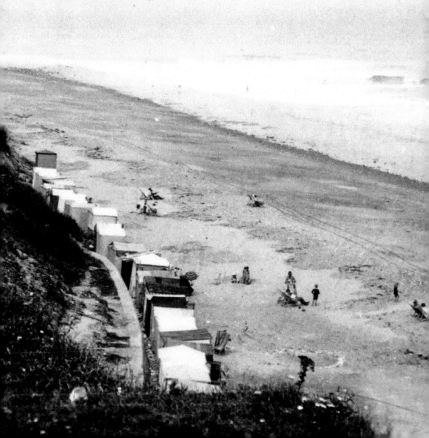

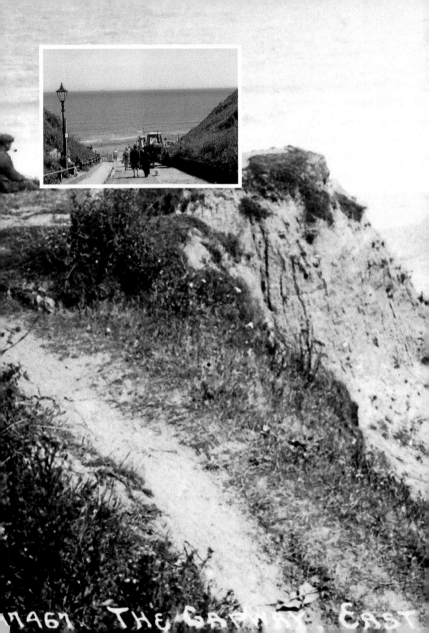

n467. THE GRANKY, EAST

25. THE GAP, EAST RUNTON

Like West Runton this was once a small fishing village and access to the beach and the sea was by this Gap. There are the inevitable caravan sites on either side at the top of the Gap, also a public car park with toilets. It is a popular place for surfers with a small lifeguard post at the foot of the Gap. On the clifftop is a surfers' memorial weather vane unveiled in 2003.

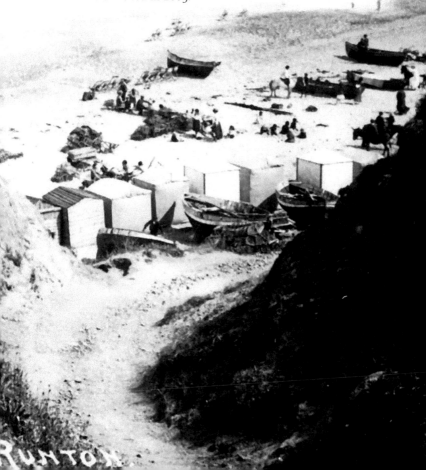

26. CROMER PIER FROM THE WEST

The small fishing village of Cromer was part of the parish of Shipden, but the sea consumed Shipden and by the nineteenth century the site of Shipden was three quarters of a mile out to sea. As early as 1779 Cromer was advertising: 'For the convenience of Gentlemen, ladies and others there is now erected at Cromer by Messrs Terry and Pearson a Bathing machine ...' After severe storms in 1843, the Revd William Sharp launched an appeal for funds and a special rate was levied on some town properties. An Act of Parliament in 1845 led to a new jetty being built and a promenade or Esplanade to protect the sea-front properties.

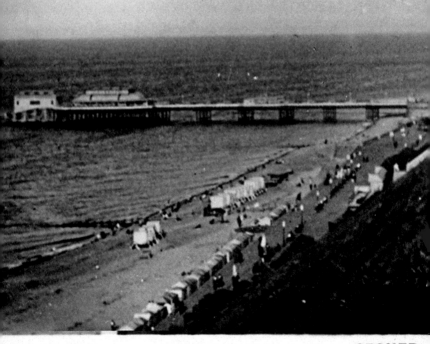

CROMER

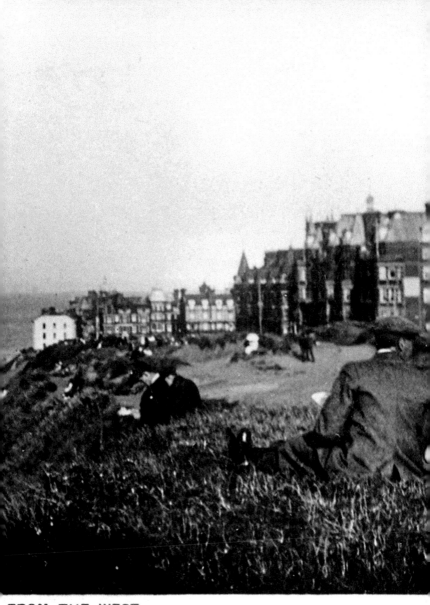

FROM THE WEST.

27. PROMENADE AND TEA ROOMS

A sloping walkway zigzags down the cliff to the promenade where there is a charming 1930s pavilion building that houses tea rooms, shops and sun lounges above. The beach huts and tents have now moved up onto the promenade. Clement Scott in 1883 described how visitors promenaded, 'It was the rule to go to the sands in the morning, to walk on one cliff for a mile in the afternoon, to take another mile in the opposite direction at sunset, and to crowd on the little pier at night.'

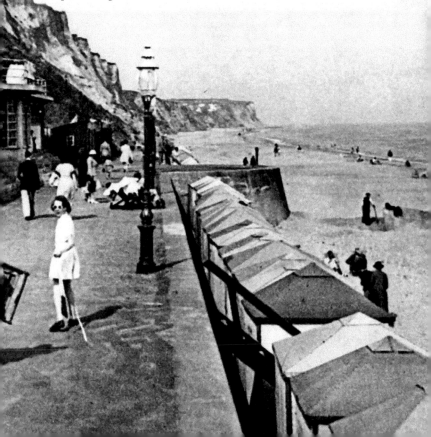

28. EDWARDIAN WEST CLIFF

Before the rapid growth of the 1890s, the reputation of Cromer as a 'select resort' was largely due to the influence of some prominent inter-related families: the Gurneys, the Buxtons, the Hoares, the Barclays and Birkbecks. All were wealthy, acquiring some of the finest houses like the Grove and Cliff Houses, but they were also religious and benevolent, concerned with the welfare of the poor. They had large families and enjoyed entertaining. They set the tone for Victorian Cromer.

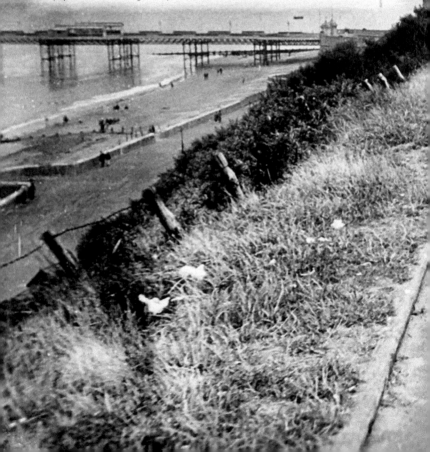

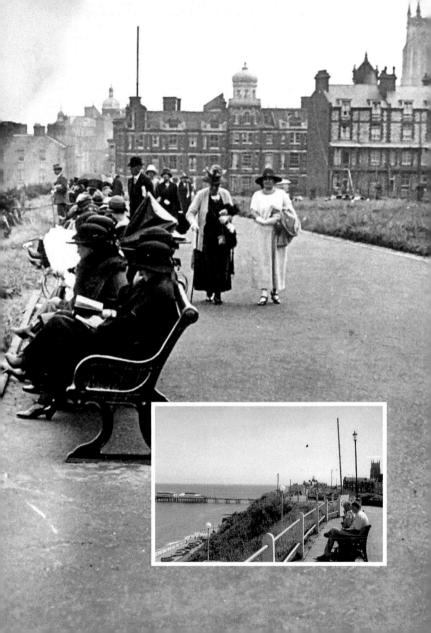

29. WEST CLIFF

Early photographs of the Grand Hotel and other Victorian hotels along the Runton Road show the area in front of them, known as the Marrams, looking quite rough and not formally laid out. Today there is a bowls club, a large putting green and colourful sunken gardens.

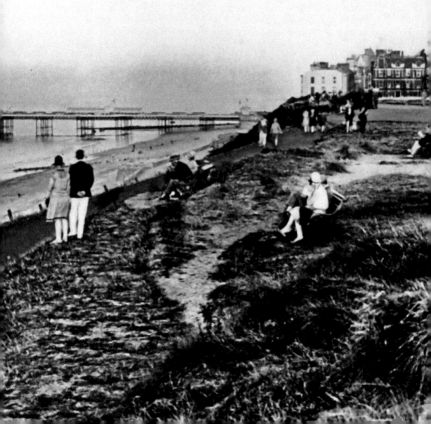

30. GRAND HOTEL

In 1890–91 George John Skipper, who had just designed Cromer's new town hall, was responsible for designing the Grand Hotel for local businessmen on land put up for auction by Bond Cabbell. In 1893–94 Skipper also designed the Metropole Hotel in Tucker Street for another syndicate. In 1969 a new owner renamed the Grand the Albany Hotel, but it burnt down that same year and was replaced by Albany Court, an example of the lack of architectural aspiration at that time.

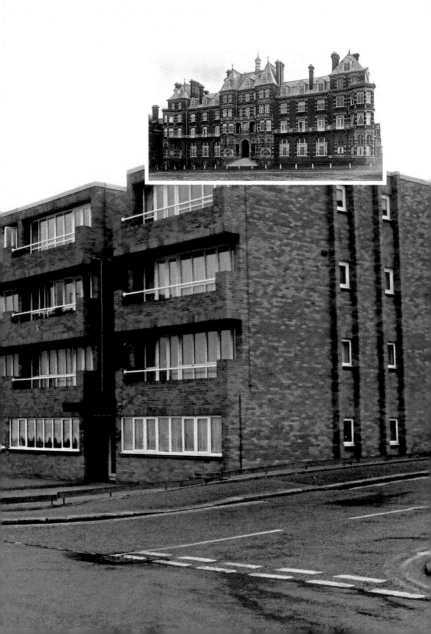

31. RUNTON ROAD AND THE CORNER OF CABBELL ROAD

Benjamin Bond Cabbell at Cromer Hall, had large estates ready for development along the West Cliff. His family encouraged the coming of the railway and owned the local brickworks. The name lives on in Cabbell Road, a magnificent Victorian street that helped link the Beach Station with the sea front. Benjamin Bond Cabbell died relatively young in 1892. More land was put up for auction and a building boom was on.

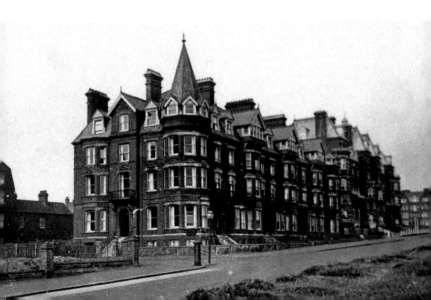

32. CLIFTONVILLE HOTEL

The same year of 1894 when the Jarvis family with George Skipper were redeveloping the Hotel de Paris as a rival to the Grand and the Metropole, the splendid Cliftonville Hotel was rebuilt on the Runton Road along from the Grand. It was not one of Skipper's hotels, but has survived and is still in business today, unlike the Grand, and the Metropole which was demolished in the 1970s.

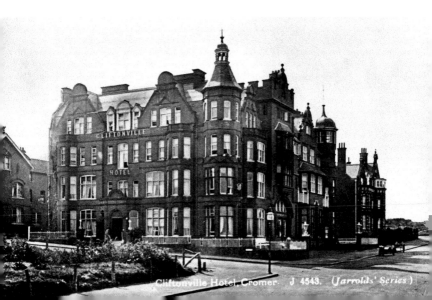

Cliftonville Hotel, Cromer. J 4543. (Jarrolds' Series)

33. WEST CLIFF SUNKEN GARDENS

Sunken gardens are a popular feature of many seaside resorts. The North Norfolk coast can be a very windy place and sunken gardens like the ones at Cromer provide shelter for both plants and people. They form a good sun trap, usually away from the more boisterous sands.

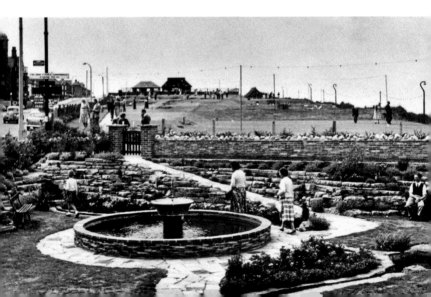

34. CROMER THE WEST BEACH

Walter Swinburne, the poet, visited Cromer in 1883 staying at the Bath House. He described Cromer as 'rather an Esplanady sort of place'. Swinburne was following Clement Scott. As part of the enhancements to the esplanade, the architects included some literary quotes, including Swinburne's words.

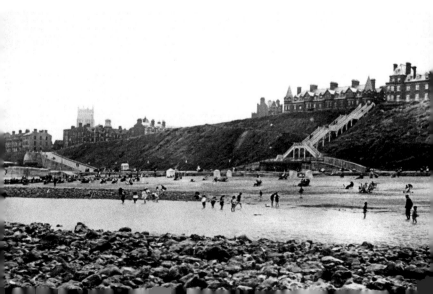

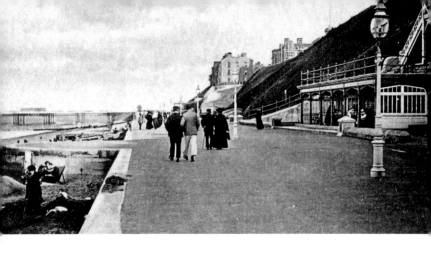

35. WEST ESPLANADE

Cromer had a reputation for gentility. The Empress of Austria stayed at Lower Tucker's Hotel in 1887. She was remembered for promenading outside the hotel, not wearing a hat, but carrying a red parasol. Everyone would bow as she passed. In 1887 Sir Herbert, Lady Beerbohm Tree and their daughter, Viola, and her nanny stayed there after the Empress. Clement Scott observed the holidaymakers, digging on the sands, playing lawn tennis, working, reading, flirting and donkey riding.

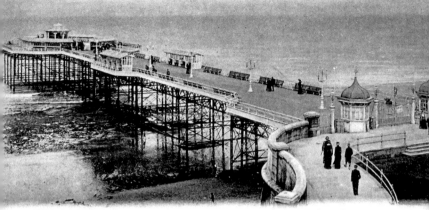

36. CROMER PIER

Edmund Bartell in 1806 described how coal ships beached at high tide and the coal was carried off at low tide in carts. For centuries Cromer had battled the sea and was losing. Wooden jetties had been destroyed and rebuilt. In 1897 a coal boat, *The Hero,* so badly damaged the jetty that it was dismantled. In 1901, a splendid new pier was opened by Lord Claud Hamilton, Chairman of Great Eastern Railway. The Blue Viennese Band played in the bandstand at the end of the pier. In 1905 the bandstand was covered and in 1906 the first concert parties took place in this pavilion.

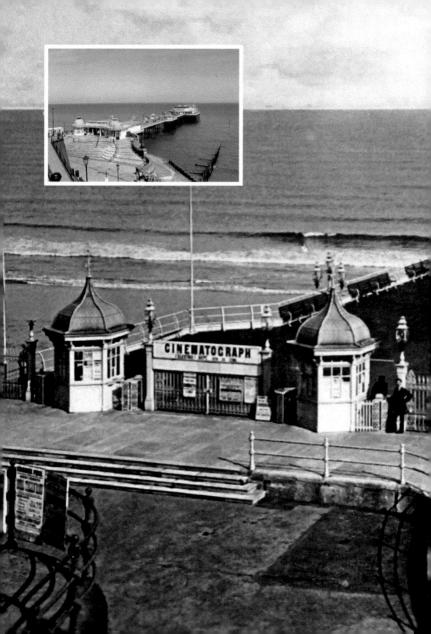

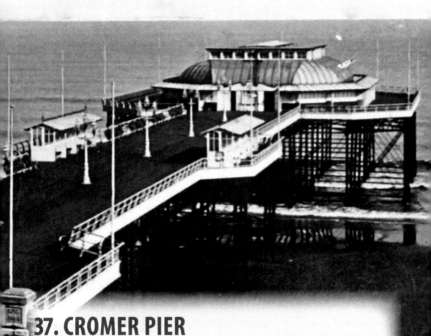

37. CROMER PIER

In 1923 a new lifeboat station was built at the end of the pier. Summer seasons of concert parties continued until the outbreak of the Second World War when the Royal Engineers removed the middle section of the pier. Shows resumed after the war. The pier and pavilion were seriously damaged by the Great Storm of 1953, opening again in 1955. In 1978 the theatre was refurbished and the popular Seaside Specials began and continue as one of the last of the traditional summer end-of-the pier shows in the country. Often battered by the sea, the pier defies the elements and symbolises the English seaside.

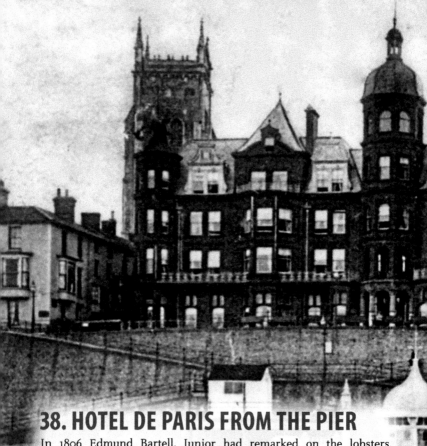

38. HOTEL DE PARIS FROM THE PIER

In 1806 Edmund Bartell, Junior had remarked on the lobsters, crabs, whitings, codfish and herrings being caught by the local fishermen. He said the bathing was good, the bathing machines very commodious, but Cromer lacked a good hotel. In 1851, however, the Belle Vue Hotel was built. In 1829 Lord Suffield's summer residence overlooking the jetty was bought by Pierre le François who ran it as the Hotel de Paris. In 1894 it was transformed along with the Belle Vue into the splendid hotel.

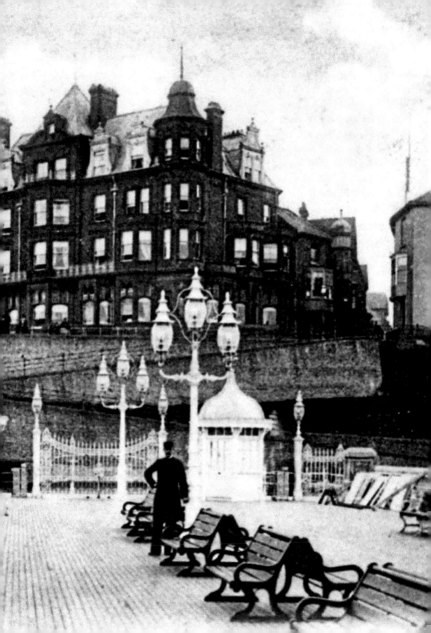

39. THE ZIGZAG

When the new pier was opened in 1901 the promenade was widened and extended. The splendid zigzag steps take pedestrians from the town down to the East or West promenade or across to the pier. The Edwardian photograph shows a bandstand and a band playing at the halfway point. At some time the area below it has been filled in.

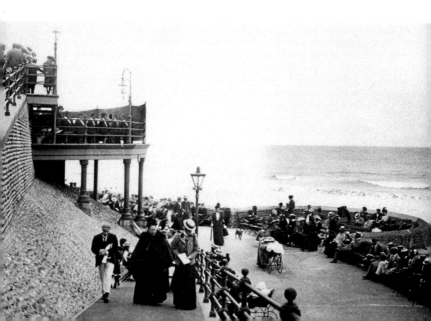

40. JETTY STREET

One of the oldest streets in Cromer. This was the route taken by the ladies to the jetty and the promenade. The bay windows at first-floor level gave visitors a view of the sea but also of the activity in the street below. When the ladies reached the jetty a keeper kept order for their safety and comfort, for example, there was to be no smoking on the jetty before 9.00 p.m. when the ladies should retire.

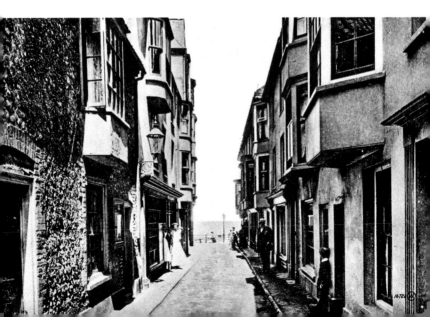

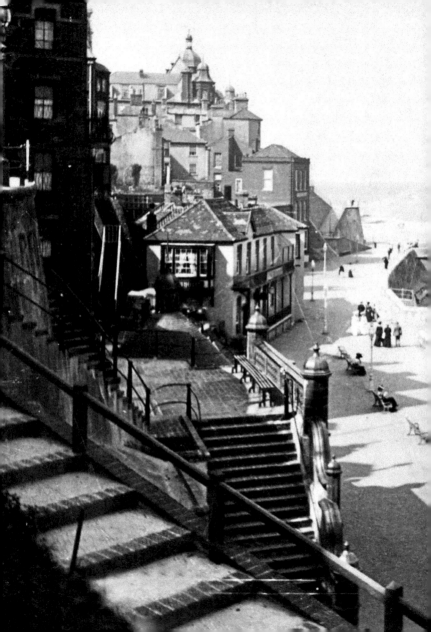

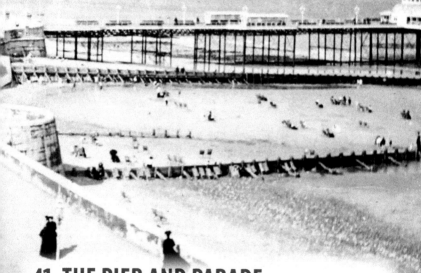

41. THE PIER AND PARADE

A magnificent Edwardian photograph capturing some of the various levels of the ways from the town to the Promenade. It also shows how the hotels and other buildings rise up from the lower level. The group of buildings on the promenade includes the Bath House Hotel and Lower Tucker's Hotel. The old Metropole once towered over them.

42. EAST BEACH AND PROMENADE

Taken from the zigzag the Bath Hotel is prominent. In 1875 Lower Tucker's Hotel, partly seen here, was built, probably in anticipation of the arrival of the railway. Cromer Station was built by the Great Eastern Railway Co. in 1877 but was outside the town as *Ward's Guide* commented: 'The traveller arriving by rail, on quitting the station, which is on high ground, a long half mile south of the town, at once obtains a good general view of Cromer...'

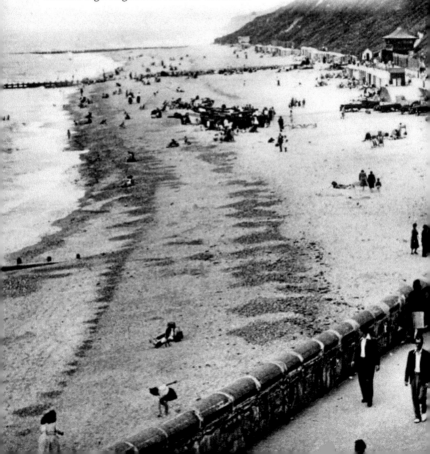

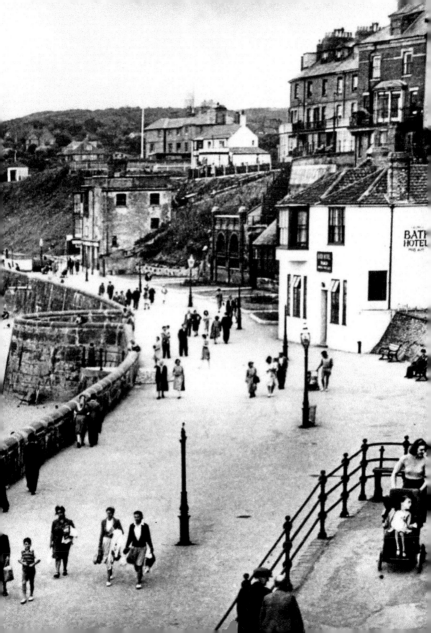

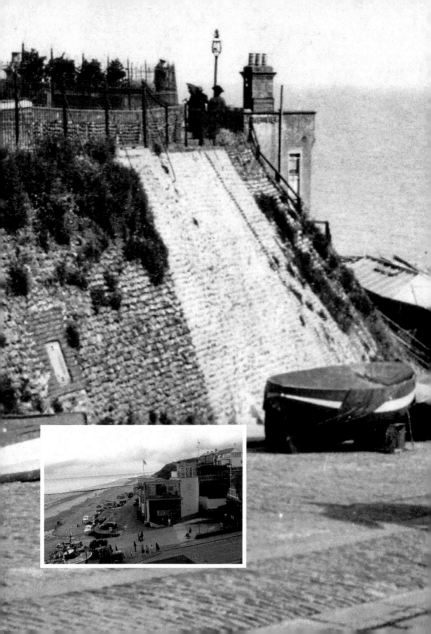

43. THE GANGWAY

The main access for fishermen and their carts, for bringing goods ashore and into the town was at the Gangway. Next to the Gangway was the lifeboat station. The fascinating Cromer Museum, close to the church, tells the story of the battle with the sea, and how the fishermen earned a living and also saved lives from the sea. The stretch of coast is notoriously dangerous with the Sheringham Shoal and the Haisbro' (Happisburgh) Sands. The Cromer Lifeboat Station, with the Tamar class *Lester* boat has always been and still is one of the most important on the British coast.

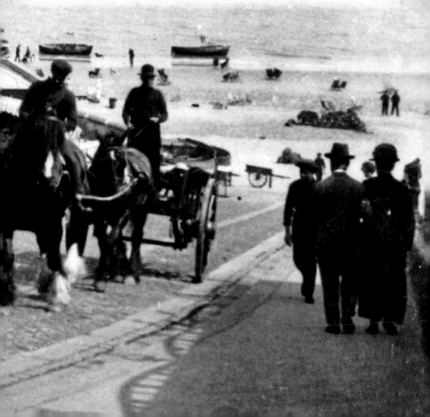

44. THE GANGWAY AND ROCKET HOUSE, 1930

The lifeboat was launched from the beach. Henry Blogg, the legendary coxswain for thirty eighty years and his crew saved nearly 900 lives. He retired in 1947 and died in 1954. He is remembered in a sculpted bust above the old lifeboat station, which describes him as 'one of the bravest men that ever lived'. A new lifeboat station was built at the end of the pier in 1923 and the old station became the Number Two with the Rocket House Café. The *George and Muriel* is the latest inshore lifeboat since 2011 and the Henry Blogg museum commemorates this true hero of the coast.

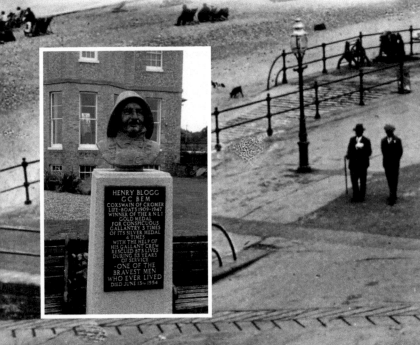

THE GANGWAY. CROMER

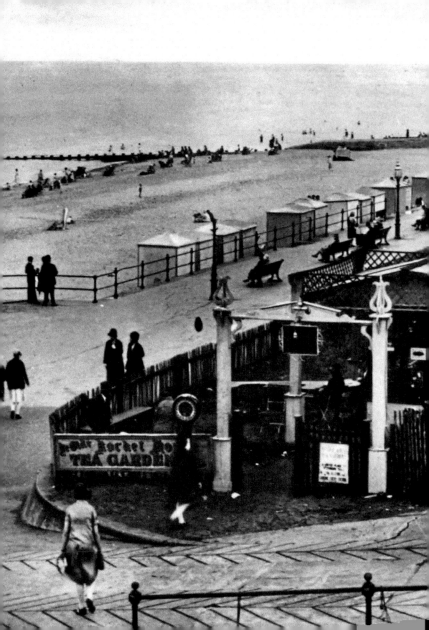

45. NORTH LODGE PARK

Once owned by the Goldsmith's Co., then the Hoare family, North Lodge, North Cottage and the Park were sold to Cromer Urban District Council in 1928. North Lodge became the council offices and other attractions for the public included two hard tennis courts, a bowling green, model village, model yacht pond and large putting green. The putting green is still in use today along with the bowling green, the model yacht pond and a children's corner. Towards the lighthouse is Happy Valley, a popular area for walking.

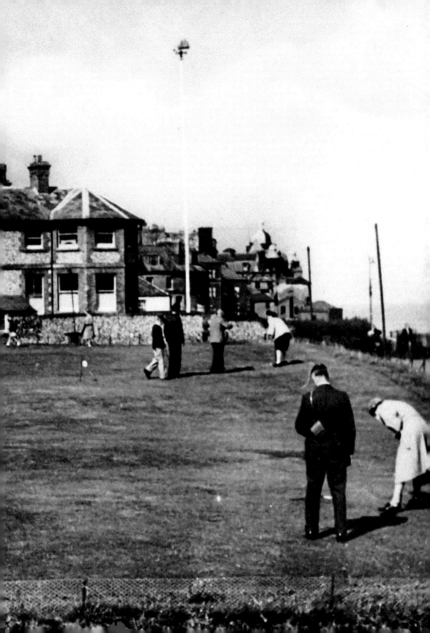

46. CROMER LIGHTHOUSE, SHOWING THE SECOND WORLD WAR RADAR MASTS

Clement Scott wrote that 'no one thought of going beyond the lighthouse; that was the boundary of all investigation. Outside that mark the country, the farms and villages were as lonely as the Highlands'. The lighthouse stands 274 feet above high water and was built in 1883 to replace the first lighthouse at Foulness which had been built in 1719 but succumbed to the erosion of the cliff and fell into the sea. This lighthouse became electric in 1958 and since 1990 has been fully automatic, monitored from Harwich.

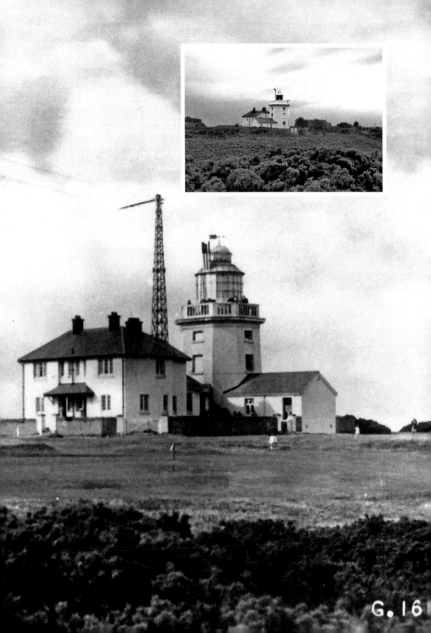

G.16

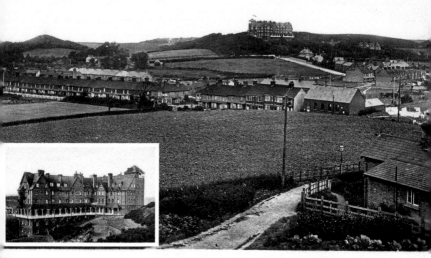

LINKS HOTEL FROM STATION, CROMER.

47. ROYAL LINKS HOTEL

The Golf Course was created in 1887; the Prince of Wales was a patron. The magnificent Royal Links Hotel stood on the course just to the south-west of the lighthouse. Sir Arthur Conan Doyle stayed at the Royal Links in 1901 and when dining at Cromer Hall with Benjamin Bond Cabbell, heard the story of Richard Cabbell, Lord of Brook Manor and Buckfastleigh who had murdered his wife on Dartmoor and then had his throat torn out by her faithful hound, the ghost of which then haunted the Moor. This was the inspiration for *The Hound of the Baskervilles*. The Royal Links Hotel was destroyed by fire in 1949. To the east lie Overstrand and the crumbling cliffs of Sidestrand immortalised by Clement Scott over 130 years ago.